RAPilates

Body and Mind Conditioning in the Digital Age

illustrations and text by CHUCK D
text by Kathy Lopez

ENEMY BOOKS

The information in this book is not intended as a substitute for professional medical advice and treatment. If you have an existing injury or any medical conditions, it is recommended that you consult a medical professional before following any of the exercises contained in this book. Neither the authors nor the publisher can accept responsibility for any injury or illness that may arise as a result of following the advice contained in this work. Any application of the information contained in this book is at the reader's sole discretion.

Published by Enemy Books/Akashic Books
Text and illustrations ©2024 Mistachuck
Text ©2024 Kathy Lopez

ISBN: 978-1-63614-174-9
Library of Congress Control Number: 2023949606

Enemy Books is an imprint of Akashic Books
Instagram: mrchuckd_pe
X: MrChuckD
rapcentralstation.net/enemy-books

Akashic Books
Brooklyn, New York
Instagram, X, Facebook: AkashicBooks
info@akashicbooks.com
www.akashicbooks.com

Table of Contents

RAPilates
How to Keep Fit to Fight the Power

by Chuck D

I'm from the last century. LOL. Meaning that when my Public Enemy career started, it was 1987. I was twenty-seven years old. I had an athletic background though I wasn't very good; I just played everything, all the time, without much focus on one sport or discipline. Didn't smoke, didn't drink, because I never wanted my already wack game to get worse. So I was a relentless energy.

From there, that attitude, that energy, transformed over to my rap style, especially in performance. Faster, harder, stronger type of thing—whether it was in the studio attempting difficult vocal takes or live onstage. We played every night back-to-back for hours. For years. And by default, this was the way my body stayed in shape: on tour. The regimen was a crude sports preparation including push-ups and sprinting.

In 1988, I stopped eating beef, and in the nineties I stopped eating chicken. I immediately felt even faster and leaner, but the truth was, I still didn't know what the hell I was doing.

I turned forty in 2000, and the nonstop touring still worked as a way to stay in shape, but a new, harder question emerged as I aged: what was the best way to maintain conditioning *off* tour. I had to figure something out home-wise—wherever that home was.

In 2012, my wife at the time suggested I try out Pilates—she had been practicing it for a while. I thought I knew something about staying in shape, thought I knew my body, but immediately upon working with Kathy Lopez, not only did I discover how far off I was, I had found something that could completely redefine my workout.

Throughout the 2010s I performed with Public Enemy and, starting in 2016, with the rap-rock supergroup Prophets of Rage as well. So conditioning and being in shape were at the top of my agenda as I started to prepare for any tour. I have a saying about the challenge of playing our sometimes difficult songs: *Either you do the songs, or the songs do you.* You have little choice when the lights pop on.

Kathy Lopez's Pilates approach and technique stretched me. Her rule is, *Don't beat your body up.* The focus on strengthening one's core not only helped with my already powerful wind control, but with my stage movement in small spaces. During a PE show, I was used to moving side to side across the entire stage, but in Prophets of Rage my movements were largely restricted to forward and backward in the small space between drummer Brad Wilk and bassist Timmy Commerford.

Kathy actually came to a few of the big shows at the Los Angeles Forum to prep me correctly. Early on, she implemented the six Pilates principles to deepen my practice both in and out of the studio. The concentration, precision of movement, and breathing really paid off during my performances. I discovered that conditioning didn't have to be about the number of reps or using a heavier set of weights like in a traditional gym—it could be about precise movements.

Kathy and I soon developed a new program aimed at maintaining my body and mind in the perpetual flow of it all. I suggested we call it RAPilates, and believe me when I say that we wouldn't be talking about this if it didn't work!

I played to over two million people in my four years touring with Prophets of Rage. Since I was the oldest member, then nearing my sixties, people were interested in what I was doing to maintain fitness. I suggested to numerous people that they try Pilates instead of beating themselves up in a gym. Many women were flocking to these classes, and the perception among a lot of men I spoke to was that it was a "women's workout."

Not.

During my initial years practicing with Kathy, I discovered how closely you must listen; how you must follow very succinctly. Because one off move can mean you're not doing a damn thing and could possibly even injure yourself. So my style was to STFU. Say absolutely nothing and do the work. Two or three times a week—not *every* day; three times a week was the perfect amount of time for me to get the most out of my training while maintaining my busy tour schedule.

Then came 2020 and the pandemic. We all became ScreenAgers. With people sequestered in their homes, the potential of Pilates was even greater, and our RAPilates program seemed perfect for the time we were living through.

Almost everyone found difficulty in their transition through COVID. Kathy

continued her Pilates coaching throughout the pandemic with Zoom lessons that reinforced everything we'd been learning face-to-face in classes. Her early explanation of how Joe Pilates had developed his art—on the mat with no equipment, using one's body weight—was now even more relevant to what everyone was dealing with in their home spaces with cameras pointing at them. This was the official cap for the purpose of RAPilates. Not everyone will go on tour and face fifty thousand people and MOVE the crowd. But the challenge is *you vs. YOU*.

RAPilates is an answer for those looking for that life-changing workout regimen. With some men, it's humbling yet motivating when you're in a class of women appearing like Olympians. Post-pandemic in these 2020s, I will boldly state that RAPilates could become, both physically and mentally, the most potent workout of this decade, if not the whole century.

Chuck D
RapArtivist
Public Enemy

Moving from Your Center
by Kathy Lopez

This book is a creative collaboration around art, Pilates, and life. Pilates is more than just an exercise program, it is an art form, an active meditation, mental therapy (for many), and quite frankly the best physical therapy you can do to restore and rehabilitate your body and mind.

Rap is also an art form, a voice for the voiceless, and a way for people across cultures to relate to one another. And it was born in New York City, just like Pilates. Hip-hop has a story to tell; it has power and is empowering.

Our intention is to introduce Pilates to rap and hip-hop communities, and to anyone else who has access to our message; to inspire and motivate people to love being in their bodies, to move their bodies, and to cherish their bodies as temples—a trifecta of mind, body, and soul.

The Pilates method has been around for over a hundred years and many of us believe it's the best core training system ever created. As Chuck mentioned, while many people think of it as a women's workout, it was created by Joseph Pilates, a very strong man who practiced boxing, fencing, wresting, and gymnastics. From its early days, Pilates has been a body-conditioning system for performers because it builds strength and flexibility. It enhances coordination, balance, and resilience, and is also known to improve posture, lung capacity, and mental focus. It doesn't tax your body like intense workouts that can drain your physical energy and create sore, tight muscles. For this reason, Pilates can be practiced every day.

Joe Pilates, who was born in 1883, wanted his methods available to the masses—to be taught in schools, hospitals, and accessible to all. He and his wife Clara had a studio in New York City on Fifth Avenue. They lived upstairs

in the same building and spent their time together mastering the Pilates system, perfecting the exercises, and gaining a deeper understanding of the body and its mechanics through the thousands of people they worked with along the way. Their students were athletes, actors, performers, dancers, and Wall Street stockbrokers; they were also ordinary people who simply wanted to be healthier and live a quality life.

Today, professionals, actors, dancers, athletes, and so many others still utilize the Pilates method as part of their fitness regimen. Joe Pilates was a genius of the body and way ahead of his time. He knew that good health starts from the inside out.

Pilates is a unique, systematic, and integrative approach to body conditioning—using body weight and springs for resistance training to strengthen and realign. It's a comprehensive program that can take a person from simple fundamental movements to very advanced skills on multiple Pilates apparatuses. (Yes, I'm taking about those crazy-looking contraptions you've seen on TV or in a Pilates studio.)

The myriad benefits include better circulation; deep, healthy breathing and increased lung capacity; strength and flexibility; healthy bones and joints; improved posture, balance, and coordination; a strong abdomen and powerful core; energy, stamina, and stress relief; reduction of body aches and pains; reinjury prevention, mainly of damaged muscles and joints; etc. The list goes on and on.

The Pilates method is based on six principles that are also found in art forms like music, martial arts, dance, theater, photography, and architecture—breath, control, precision, centering, concentration, and flow. They can help shape and guide your inner and outer self to stay balanced in a world of chaos, stress, and constant change. There is an order to the exercises, and between each there is a transition, to move from one exercise to the next. There is also coordination between your breathing and movements.

The practice of Pilates is about learning to move from your center, also known as your "powerhouse," a term coined by Joe Pilates that refers to the core muscles, including the hips, abdominals, and shoulder girdle. His method

teaches that all movement starts in the powerhouse. Not only does this improve posture, strength, stamina, flexibility, and balance, it also helps us create bigger and more explosive moves. In recent years, the ideas of "core strength" and "core training" have become very popular and are used somewhat interchangeably with "powerhouse," but they're not the same.

Each exercise is meant to be performed along with a breath that engages your powerhouse. Like any other skill you have learned—riding a bike, driving a car, playing a sport—the way you practice or train becomes automatic over time. In Pilates, deep breathing with each exercise eventually becomes second nature and it helps engage your powerhouse.

"Flow" and natural movement stem from all of the other principles. When you can control your movement and breathe naturally, you will feel an organic rhythm and flow. Deep, slow breathing also helps to detoxify and energize your body. Pilates requires you to "wring out" your lungs, which is what creates the increased lung capacity. Your intercostals will become more flexible between your ribs, which creates a tighter waistline and rib cage, and improves your posture. Diaphragmatic breathing increases vocal capacity as well.

I could write a whole book on the powerhouse alone, but for the purposes of this volume, we have included a bit more information in the glossary at the back.

Chuck D and I met fourteen years ago when he walked into my studio to start his Pilates journey. In those days, few men were exploring Pilates, so I was surprised when a hip-hop star from New York City showed up. I was excited about the challenge of working with this legendary artist, who also turned out to be one of the nicest and most down-to-earth guys around.

Chuck was just entering his fifties, and the previous twenty-five years of performing onstage and constantly traveling were taking a toll on his body. He wanted to get physically fit so he could perform well into the future. Age is no joke—it creeps up on us, we start having aches and pains, we get stubborn belly fat, and we suffer from low energy.

When I asked Chuck what types of workouts he'd done in the past, he told me he had played basketball growing up and currently had mini hoops in his office as a way to keep himself moving throughout the day, giving him a reason to get up from his desk. For Chuck, Pilates was a completely new art form and a new language for the body; it was vastly different from anything he had ever done. Since he had no real formal fitness training, his body and mind were like a blank canvas, ready for transformation.

He took everything in, and I could see his mind working and his body trying to keep up. It turned out that Pilates was a perfect fit for Chuck because

of his years of performing and understanding the power of repetition. It also worked well with his busy schedule—he could get a full-body workout in one hour or less, a few times a week, and never felt too sore or exhausted the next day for rehearsal.

So many of Chuck's friends in the hip-hop world were dying too young, one after another. Chuck was feeling heartbroken and wanted to use his platform to educate and inspire health, fitness, and wellness. His initial vision for RAPilates was born in 2012—using my personal approach and experience to customize his program, evaluate his progress, and see and learn from what his body was telling me. I used creative imagery and cues to guide his movement and get him to connect with his powerhouse. He was an exceptionally good student, and most of the time he practiced Pilates with his eyes closed, feeling his body from the inside out. It would look like he was in a deep state of meditation, in his own world. There were even times when he would tune *me* out! I didn't mind at all, because it was his own process to discover Pilates.

While the focus of RAPilates, as you'll see, is exercises on a mat, I initially started training Chuck on the Pilates "Reformer"—one of the apparatuses that Joe Pilates developed. The Reformer is one of the best ways that I can assess a student's body and movement. (See the glossary for more details on the Reformer.) I started Chuck on footwork, and the Reformer is an excellent way to do that. Since Pilates is practiced in sticky socks, your feet feel everything—like reflexology. That is what Chuck needed after years of jumping around on stages. The feet are where knee and hip problems can start, so footwork is essential for keeping proper balance and stability, especially as we age.

The Cadillac is another Pilates apparatus I have used regularly with Chuck. Joe Pilates once said, "It's called the Cadillac because it has everything and does everything"—like the luxury car back in the 1920s. I first put Chuck on the Cadillac to help him stretch his shoulders after years of swinging a mic and fist-pumping, along with many hours of writing and traveling. He quickly began to appreciate the personalized and detailed nature of this approach.

Chuck loved how elongated and stretched he felt, and how uplifted his energy became, after a Pilates session. I routinely had him practice breathing as well, learning to inhale laterally into his rib cage while holding in his abdominals. This is known as the Pilates breath.

Not long after his Pilates transformation began, Chuck started searching for ways to eat better when he was on the road, natural ways to improve his hydration, immunity, and brain function. He soon identified the right foods and supplements that would help to boost his performance and health.

When Chuck joined Prophets of Rage in 2016 and began learning new lyrics, he would sometimes whisper the lines during his Pilates workout—I guess you can call that being in the flow! He trained vigorously, both in the recording studio and the Pilates studio. And on top of it all, he always made time to drop off and pick up his youngest daughter from school. That's a man on a mission.

I'm happy to report that the Prophets of Rage tours were successful, and most importantly, Chuck went injury-free throughout.

When COVID came around, those dark and scary times taught us what we already knew and had been practicing for years through Pilates principles: breathing is our life force; concentration is essential for keeping ourselves in the present moment and not living in fear; and movement from our center is paramount in releasing negativity built up from a world in turmoil.

Sessions with my students were moved to Zoom, and we did our workouts in our homes, on mats. Chuck and I trained three times a week for thirty minutes per session. We made every day count and stayed connected. We created a rou-

tine and as much normalcy as possible. So many of my students stayed strong, or got stronger, and learned to take more accountability for their workouts. Exercising during the pandemic was crucial for increasing a positive mood and outlook.

So, it is my great pleasure to share with you this RAPilates mat program that helped me, Chuck, and my other students get ourselves through the pandemic, and will surely continue to help with all of life's future highs and lows.

Kathy Lopez, owner of Studio Be Pilates
www.studiobeventura.com

Certifications:
Pilates: Body Arts and Science International (BASI), Power Pilates, Classical Pilates

Yoga: AIReal®, Iyengar Yoga

Personal Training: National Academy of Sports Medicine Personal Training (NASM PT) and Corrective Exercise Specialist (NASM CES)

Fitness: TRX Suspension Training®, TRX RIP Training®, BootyBarre®, and Johnny G Spinning

The RAPilates Mat Program

33 Exercises to Strengthen Your Body and Mind

The following program is based on Joe's original Pilates exercises and features a combination of beginner, intermediate, and advanced levels. If you are a newcomer to Pilates, you will have the best experience if you take a beginner-level class at a local studio or a private lesson with a professional teacher. Please use caution if you have health concerns and check with your doctor before starting any new exercise program.

The Benjamins (aka Hundred)

Lie on your back with your knees bent into your chest.

Curl your head, neck, and shoulders up to bring your forehead toward your knees; extend your legs out straight to 90 degrees, and reach your arms out long and straight by the side of your hips.

Start pumping your arms up and down vigorously in time with your breath. Breathe in through your nose for 5 pumps and out through your nose for 5 pumps.

Do 10 sets—10 sets equals a hundred $$$.

Stay focused on keeping your abdominal muscles pulled in, as if you are putting on a tight belt and buttoning up a vest, very snug. Pumping your arms creates the heat to blast your metabolism—think of your breathing like a bellows fanning the fire.

Pro Tip

Inhale and count 5 arm pumps, then exhale and count another 5 pumps; breathing deeply will detox your lungs and let some steam out.

Benefits

Gets your circulation going and warms you up for the next exercise.

Bankroll Y'all (aka The Roll-Up/Rollback)

It is recommended to start with the Rollback before you attempt the Roll-up.

Sit up tall with your legs straight out in front of you (slightly soften your knees if necessary to sit up straighter on your sit bones). Reach your arms out long and straight at shoulder level with your palms facing down.

Nod your chin to your chest and start slowly rolling back, using your abdominal muscles to curl your tailbone under.

Roll your curved spine toward the floor one vertebra at a time (lower vertebrae hit first, followed by middle and upper back).

When beginning, only roll back to a place where you can then roll back up using your abdominal muscles. The goal is to roll all the way down to the mat flat and back up using abdominals throughout.

Pro Tip
Keep your spine in a tall C-curve by drawing your abdominal muscles in and up.

Benefits
Strengthens the powerhouse and lengthens the spine and legs.

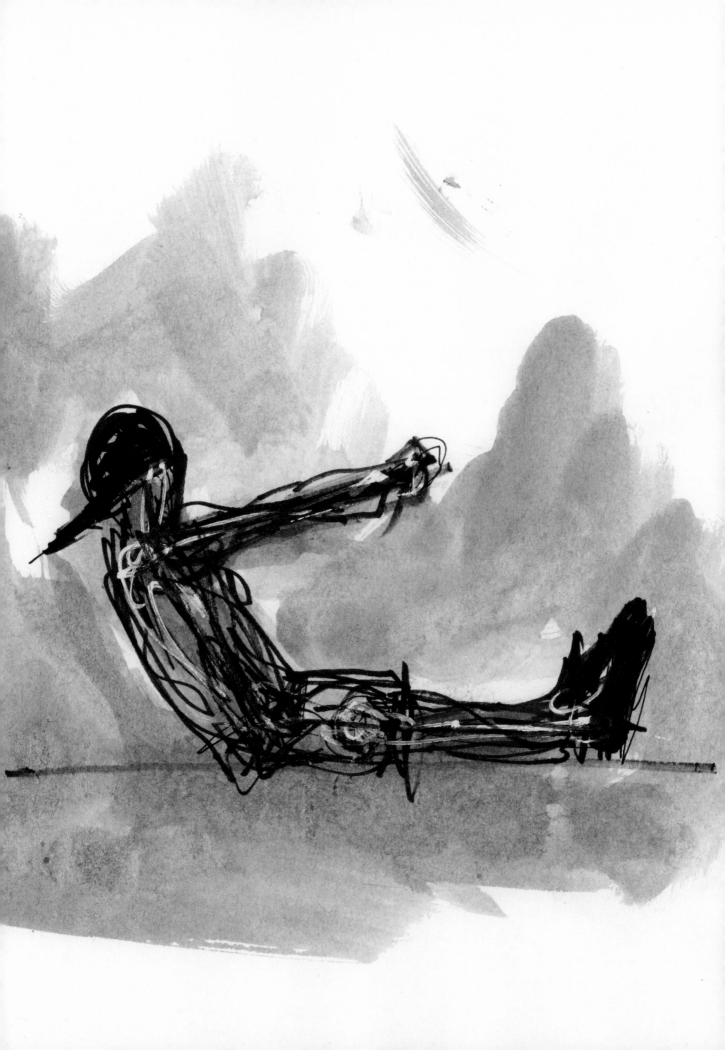

High Rolling (aka The Rollover)

Lie on your back with your hands under your tailbone and your legs reaching up to 90 degrees.

Draw your abdominal muscles in as you squeeze your legs, hips, and buttocks and lift your hips and straight-ish legs up and slowly over your head, lowering your feet slowly toward floor behind your head (they do not need to touch the ground).

Don't rush the rollover part, start with simple leg lifts as long as it takes until you can lower and lift your legs easily without the support of your hands under your hips.

Pro Tip

Try doing big leg circles before rollovers. Lie on your back with straight legs pointed up to the ceiling; lower them down toward floor with ankles squeezed tight; go as low as you can without arching your back; open them about the width of a yoga mat, and circle them up to the top, ending with ankles tight together at the top. 5 circles in one direction and 5 circles in the reverse direction can help open up your hips and lower back.

Benefits

Strengthens the powerhouse and upper body; also lengthens the spine.

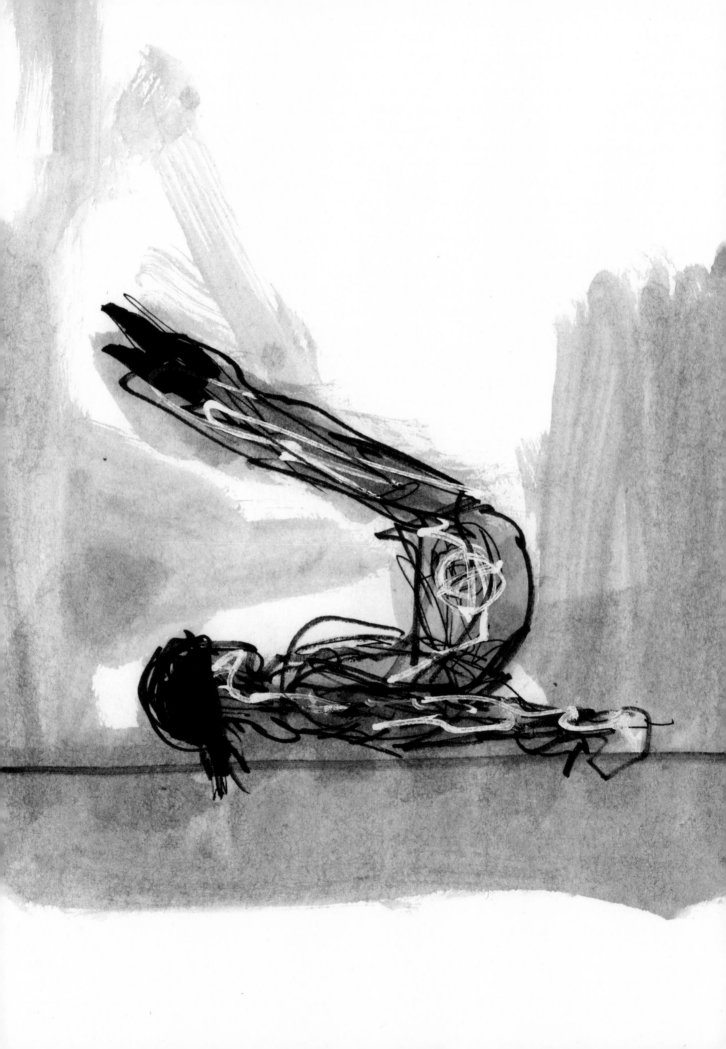

The Hip Swinger (aka Single-Leg Circles)

Lie on your back with 1 leg pointed straight up toward the ceiling and the other leg straight down on your mat.

Breathe in as you cross your top leg over your bottom leg and across your hip belt.

Exhale as you circle your leg down, around, and back up to the starting position; then reverse the same leg, circling in the other direction

Do 5–10 reps in each direction. Repeat on the other leg. Focus on using your abdominal muscles to draw the circles and trying to keep your pelvis as stable as possible.

Pro Tip

Focus on stabilizing your hips by using your abdominal muscles and inner thighs. This creates circulation and releases creativity in the brain.

Benefits

Strengthens the powerhouse, legs, hips, and lower back.

Rolling Like a Baller (aka Rolling like a Ball)

Start in a seated position with knees bent into your chest while holding onto the back of your thighs. While staying in this tucked ball-like shape, lift your feet a couple inches off the floor, pull your abs up and in, and roll back toward the tips of your shoulders, keeping the tight ball shape, then roll up to the start position, ideally without letting your feet touch the mat at the top.

Breathe in and out through your nose, keeping the shape of a C-curve/ball as you roll slowly back and forth.

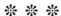

Pro Tip

Go slowly and allow your breath and pulling your abdominal muscles in to move you. Try not to use momentum.

Benefits

Massages the spine, strengthens the powerhouse, and improves balance.

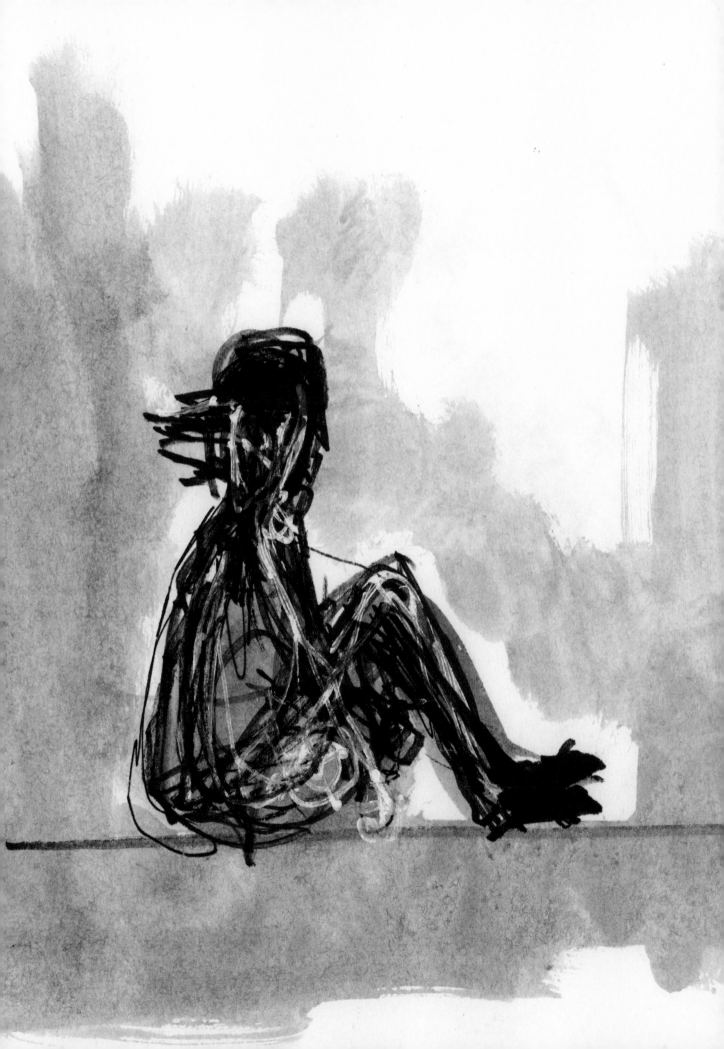

The next 5 exercises are "The Killer of 5,"
aka "The Series of 5." These abdominal exercises are
meant to be done daily to strengthen your powerhouse.

1. Stretch 'Em Out, Stretch 'Em Out, Stretch 'Em Out! (aka Single-Leg Stretch)

Lie on your back with both knees bent into your chest and your hands on your shins.

Nod chin to chest and curl your head, neck, and shoulders up; extend one leg straight out in front of you (roughly 45 degrees) while holding onto the other one, pulling it tightly into your chest.

Inhale to prepare, switch legs as you exhale.

Do 10 reps on each leg.

Pro Tip

Keep your focus on pulling your abdominals in as you breathe. If your neck is tight, keep your head down while doing the exercise.

Benefits

Strengthens the powerhouse and lengthens the legs.

2. Fight the Power (aka Double-Leg Stretch)

Start on your back and pull both knees into your chest with your hands on your ankles.

Curl your head, neck, and shoulders up, and bring your forehead toward your knees.

Draw your abdominals in and inhale as you extend your legs out in front of you while moving your arms up and back above your head, then exhale as you draw your legs and arms back into the start position. Keep your tailbone down, and use your abdominals as you reach your arms and legs out and in.

Do 5–10 reps.

❋ ❋ ❋

Pro Tip

Stay focused on drawing your abdominals up and in as you stretch and breathe.

Benefits

Strengthens the powerhouse.

3. Get 'Em Up, Get 'Em Up (aka Scissors)

Start by lying on your back and hugging both knees into your chest with head, neck, and shoulders curled up.

Extend your left leg up to the ceiling and reach for your ankle with both hands; extend the right leg out in front of you to roughly 45 degrees.

Inhale to prepare, exhale as you switch your legs, scissoring them to work from your abdominals and inner thighs.

Do 10 reps on each leg.

Pro Tip

Ring out your lungs when you exhale. Concentrate on keeping your tailbone down and your legs as straight as possible. Head up or down is fine.

Benefits

Strengthens the powerhouse and lengthens the legs.

4. Gotta Keep Ya Legs Up (aka Double Straight-Leg Stretch, aka Lower Lift)

Lie on your back and extend both legs up to the ceiling.

Curl your head, neck, and shoulders up.

Inhale as you slowly lower your straight legs toward the mat.

Exhale as you bring them slowly back up to the start position.

As with all "Series of 5" exercises, focus on keeping your tailbone down and your spine long on the mat.

Pro Tip
For lower back support, place hands under your tailbone as you do this exercise.

Benefits
Strengthens the powerhouse.

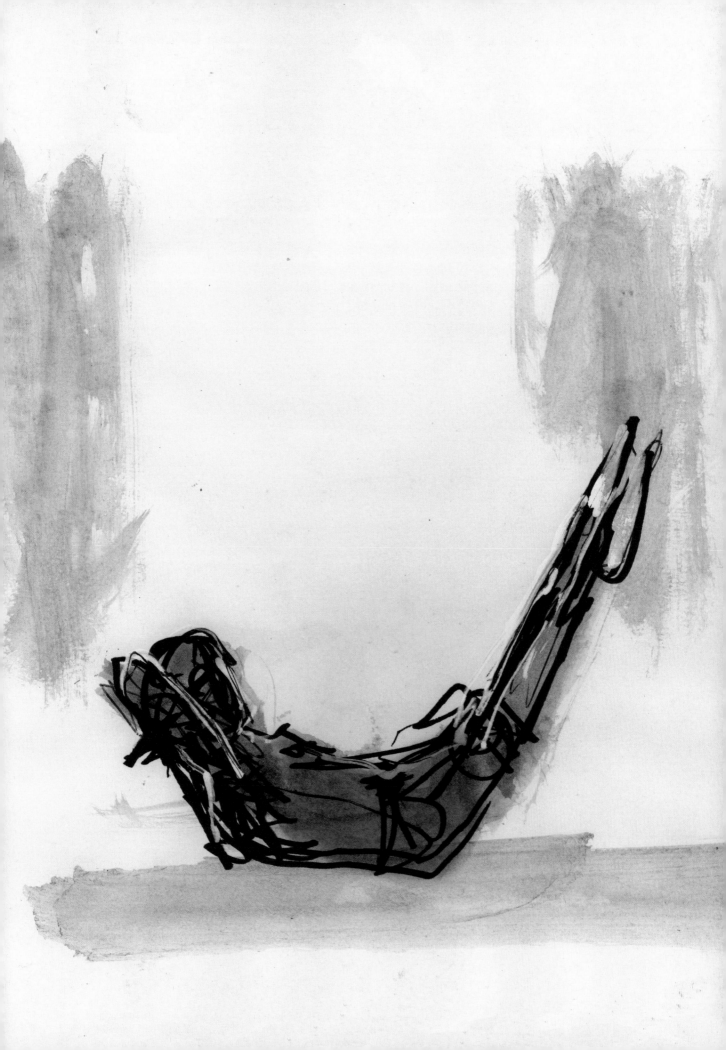

5. Three Slow Hail Marys (aka Crisscross)

Lie on your back and bend your knees into your chest; curl your head, neck, and shoulders up with fingers interlaced behind your head.

Extend your right leg out straight to 45 degrees while keeping your left leg bent into your chest.

Stay curled up at your chest as you cross your right shoulder toward your left knee, creating a crisscross bicycle type of movement, then switch legs as you cross over to your other side. This movement pattern is known as "bicycles."

Do 10 reps on each side.

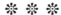

Pro Tip

Keep a steady flow and create an X across your body, lifting and twisting from your waistline.

Benefits

Strengthens the powerhouse and sculpts the waistline.

Channel Zero (aka Spine Stretch Forward)

Sit tall with your spine stacked vertically, like you're sitting against a wall, legs shoulder-width apart and feet flexed with your hands on the mat between your thighs.

Begin with an exhale as you lower your chin to your chest to roll your spine forward, one vertebra at a time, while you slide your fingers on the mat all the way toward your feet or as far as you can go.

Then inhale to stack your spine all the way back up to vertical, slowly sitting up straight against the imaginary wall.

Pro Tip

Keep your powerhouse drawn in and your spine elongated as you roll up and down.

Benefits

Lengthens the spine and legs and strengthens the powerhouse.

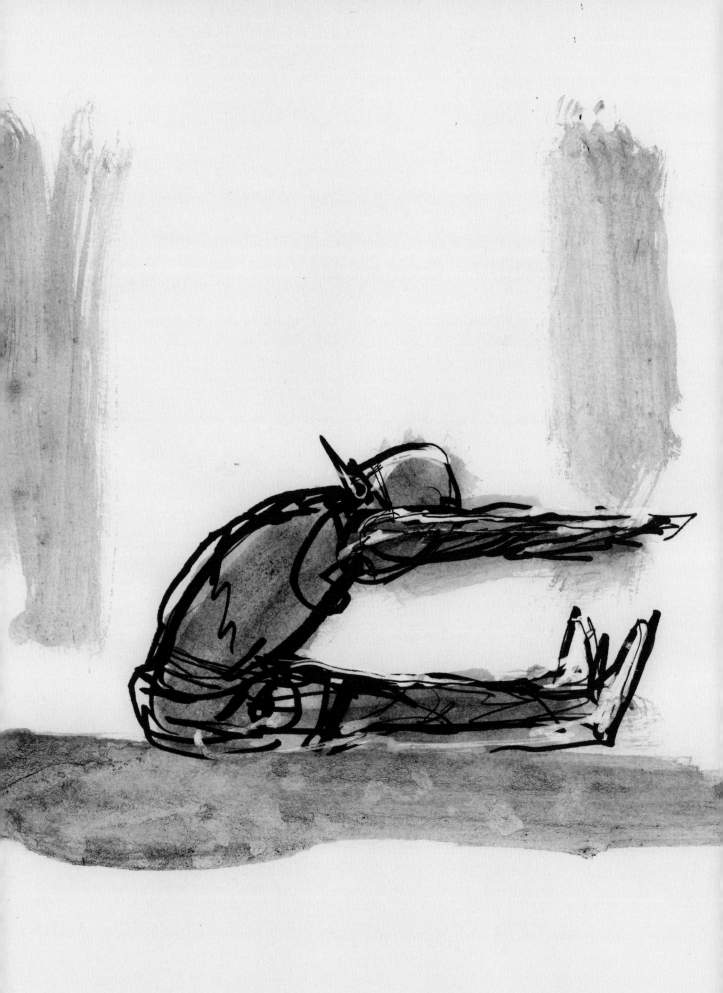

Aww Yeah! (aka Open-Leg Rocker)

Start seated, balancing on your tailbone with your legs bent at 90 degrees; open your legs shoulder-width apart and lifted just off the mat.

Hands can be placed on shins or ankles, with legs as straight as possible.

Curl your tailbone under, breathe in deeply, and slowly rock back over your tailbone toward your shoulders while maintaining a C-curve spine; exhale as your rock back up slowly to the start position.

Inhale and exhale to stabilize and balance at the top, and then repeat.

Do 5–10 reps.

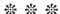

Pro Tip

This exercise is modified for beginners and is still incredibly challenging for most people.

Benefits

Strengthens the powerhouse, massages the back, improves balance, and lengthens the spine and legs.

Bum Rush (aka The Corkscrew)

Lie on your back with your legs pointed straight up to the ceiling, while pressing your arms long at your sides and into the mat.

Pull your powerhouse in and inhale as you circle your legs to the left, down, and up around to the right; exhale as you bring them back up to their starting position.

Stabilize your hips as you move your legs; imagine your torso is anchored to the mat like a seat belt bolted across your hips.

Reverse the direction of the circle each time, inhaling as you begin and exhaling as you complete the circle. Repeat 3–5 times per side.

Pro Tip

Keep your back flat and stable on the mat with each rep and your legs glued together throughout the exercise. Try to keep the pressure off your neck. End by bending your knees into your chest for a recovery stretch.

Benefits

Strengthens your powerhouse, stretches your back, and improves balance.

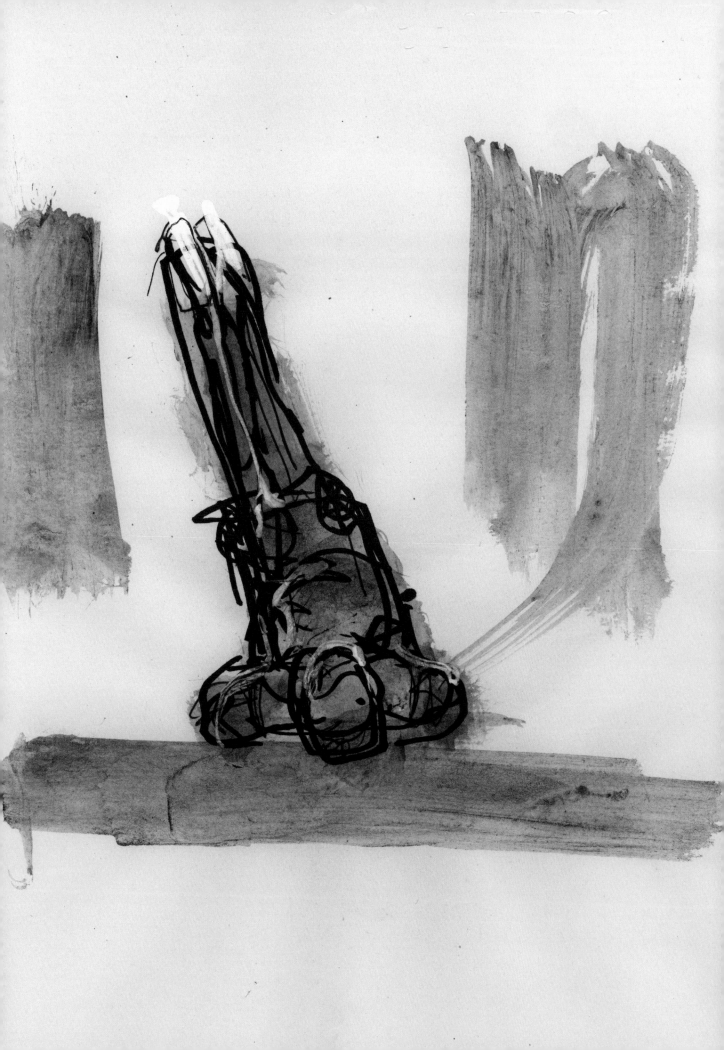

Can't Truss It (aka The Saw)

Sit up tall with your legs opened just a bit wider than shoulder width.

With feet flexed, extend your arms out to the sides at shoulder height.

Twist your torso to the left and bend forward, pointing your forehead toward your left knee.

"Slice" the outside of your left foot with your right hand (palm facing away from your foot), while your left arm reaches up to the sky with your palm facing up.

Exhale all of the air out of your lungs, return to center sitting up taller, and repeat on the other side.

Do 5 reps on each side.

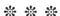

Pro Tip

Twist at the waist and keep your hips stable while extending your arms and spine.

Benefits

Strengthens the powerhouse, stretches the spine and legs.

Don't Believe the Hype (aka Swan Dive)

Start by lying on your stomach with your legs extended long behind you.

Place your palms facedown under your shoulders, draw your powerhouse in, lift your head and chest up while drawing your shoulders down your back, and shoot your legs straight out behind you.

Then begin rocking back and forth, inhaling as you lift your chest and rock backward, and exhaling as you rock forward and lift your legs up slightly behind you.

Do 5–10 reps.

Pro Tip

(Skip this exercise if you have a bad back.) Try to maintain a rigid, tight body, with your legs glued together and arms extended in front of you, while rocking back and forth; use your breathing to lift and power your movement.

Benefits

Strengthens the powerhouse, back, and buttocks, and lengthens the spine.

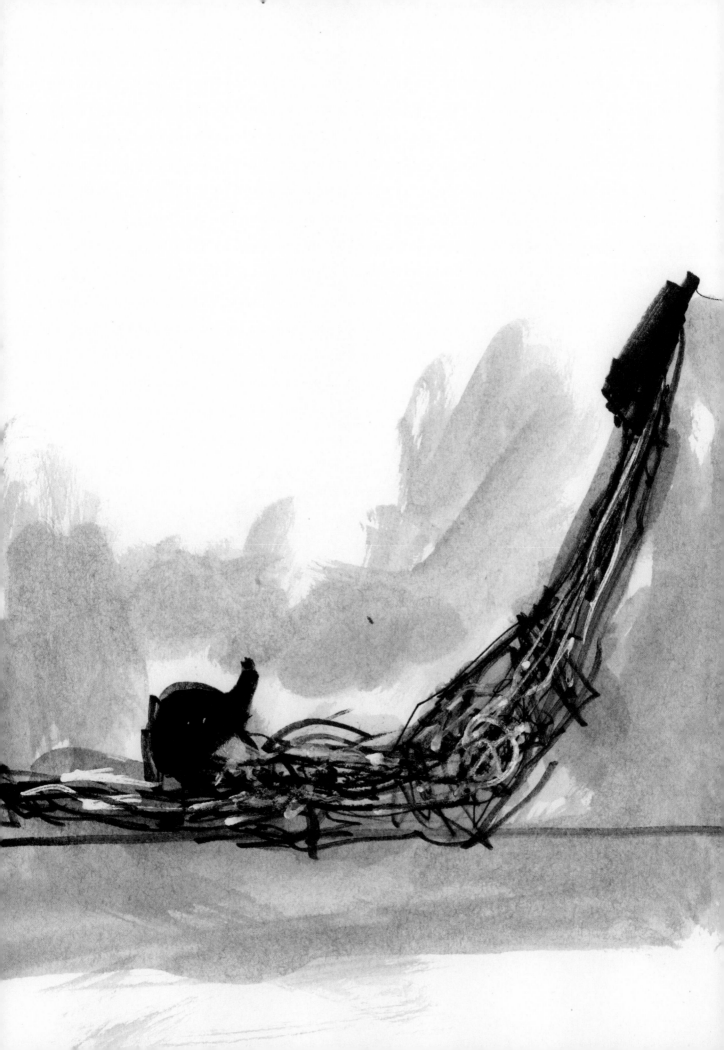

Stay Still & Kick It (aka Single-Leg Kicks)

While lying on your stomach, prop yourself up on your elbows (elbows should be parallel to each other).

Lift and open your chest and keep your shoulders sliding back and down; keep your pelvis heavy and stable.

Extend and lengthen straight legs out behind you with your feet slightly lifted off the floor.

Inhale, kick your right leg two times toward your buttocks, then extend back down; repeat on the other side.

Do 5–10 reps.

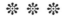

Pro Tip

Stay lifted and stable in your torso as you kick your heels into your bottom.

Benefits

Strengthens the powerhouse, back, shoulders, arms, and buttocks.

State of Mind (aka Double-Leg Kicks)

Start lying facedown with your right cheek on the mat and your hands interlaced and resting behind you on your lower back.

Inhale as you bend both knees and exhale as you kick both your heels to your buttocks twice.

In one motion, extend your legs long behind you and straighten your arms behind you, reaching toward your feet, and lift your chest off the mat, opening your shoulders and hips.

Return to the start position and put your left cheek on the mat (alternating between kicks).

Do 5–10 reps.

Pro Tip

(Skip this exercise if you have a bad back.) Keep your pelvis imprinted into the mat and your abdominals in as you kick your heels to your bottom, then extend your body long as you lift your chest with your abdominals pulled in toward your spine.

Benefits

Strengthens the powerhouse, back, and buttocks; opens the chest, shoulders, and hips.

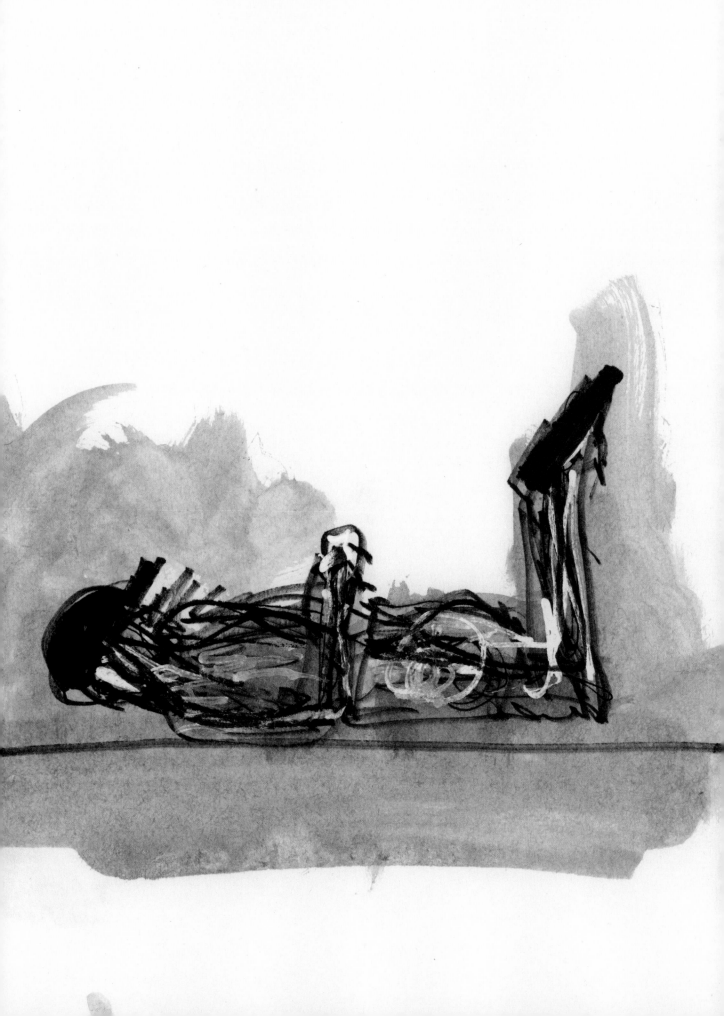

He Got Game (aka Neck Pull)

Start seated with your legs shoulder-width apart in front of you, with knees slightly bent and heels digging into the mat. Interlace your fingers behind your head.

Nod your chin to your chest and slowly roll back toward the floor, pushing your legs and heels into the mat as your roll all the way down.

Once you reach the floor, slowly open your elbows wide to open your chest, and inhale.

To roll up, exhale and engage your powerhouse, and dig your heels into the mat while curling yourself up one vertebra at a time.

Go slowly and, if needed, use your hands a bit or bend your knees more to help roll up. (This is a very challenging exercise.)

Once up, fold forward and bring your head between your legs.

Inhale and sit up tall. Repeat 5 times.

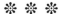

Pro Tip

Keep your legs anchored to the mat; push through your heels to roll up and roll back down.

Benefits

Strengthens your powerhouse, elongates your spine and legs.

Bring the Noise (aka The Scissors)

Lie on your back with your legs extended on the mat. Start by lifting your legs straight up to the ceiling, and continue lifting them up and over your head. Place your hands on the back of your hips and move your legs back to point straight up to the ceiling.

Pull your powerhouse in and squeeze your hips to secure your position. Inhale, then lower one leg toward the mat and the other one over your face to scissor your legs slowly.

With each scissor, pulse your legs slightly without wobbling in your powerhouse. Inhale as you switch legs by scissoring them past each other, and exhale along with two tiny pulses.

Complete 3 sets of scissors.

Pro Tip

(Skip this exercise if you have any issues with your neck, shoulders, or wrists.) Stabilize your hips while your legs scissor and don't allow the weight of your body to rest solely on your shoulders or hands. Keep your legs straight using your powerhouse.

Benefits

Stretches your hip flexors, quadriceps, and hamstrings while building strength in your powerhouse and increasing the flexibility of your spine.

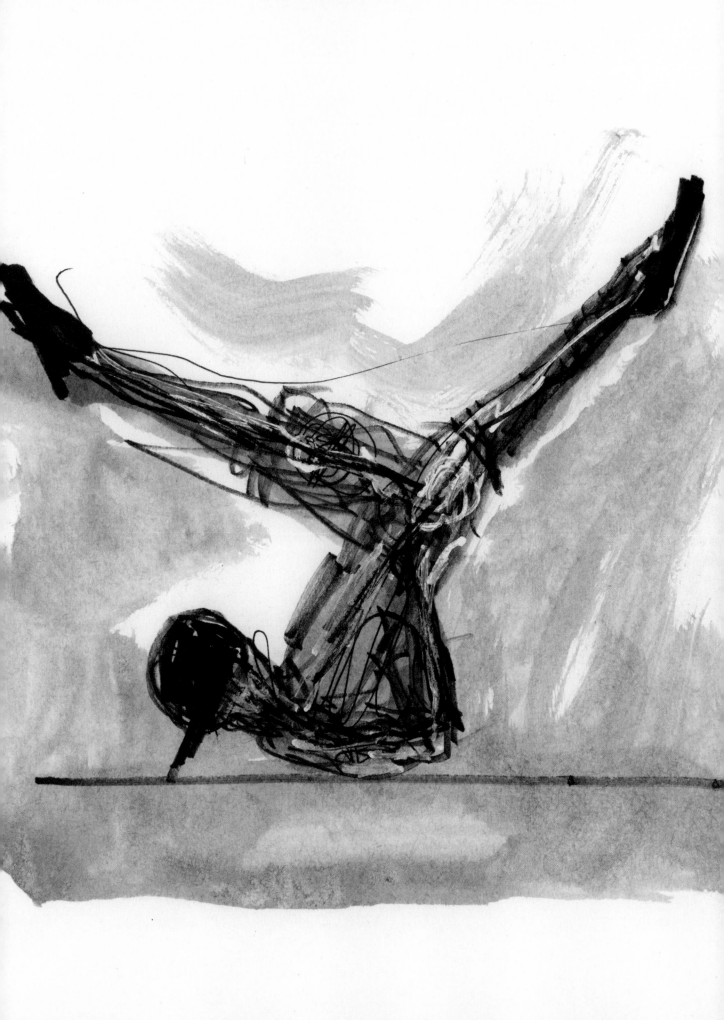

Ride or Die (aka The Bicycle)

Start in the same position as "Bring the Noise" and move your legs in huge circular motions as if on a bicycle.

Do big bicycling motions with your legs 5 times in one direction (pedaling forward), and then switch and do 5 more in the other direction (pedaling backward).

Keep the weight off your neck and press down firmly into your shoulders and the back of your arms.

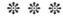

Pro Tip

(Skip this exercise if you have a bad back, neck, wrists, or shoulders.) Remain very stable and lifted in your hips as you perform the cycling movements.

Benefits

Strengthens the powerhouse and legs; opens the chest and hips.

High-Bootie Gangster (aka Shoulder Bridge)

Lie flat on your back with your knees bent (ideally over your ankles) and arms long at your sides.

Exhale as you curl your tailbone up and off the mat one vertebra at a time, rolling up to your shoulder blades.

Inhale to elongate your arms and spine.

Exhale and lift your right leg up, with toes pointed, to 90 degrees.

Inhale as you lower your leg to ankle level.

Exhale, flex your foot, and bring it back up to 90 degrees.

Repeat 10 times on each leg.

❋ ❋ ❋

Pro Tip

Keep your hips level and pull your powerhouse in.

Benefits

Strengthens the legs, hips, buttocks, and back; also stretches the chest and hips.

Rebel without a Pause (aka Spine Twist)

Sit up tall with your legs extended straight out in front of you, squeeze your buttocks, and extend your arms straight out to the side.

Exhale as you twist twice to the right and inhale back to center, then exhale and twist 2 times to the left and inhale to return.

Do 3–5 reps.

❊ ❊ ❊

Pro Tip

Root down into your hips as you spiral upward to twist and wring out your lungs to detoxify and release the stale air.

Benefits

Strengthens the powerhouse.

Public Enemy No. 1 (aka The Jackknife)

Lie on your back with your legs extended up to the ceiling.

Exhale and press your arms into the floor as you curl your hips over your shoulders (extending your legs straight up toward the ceiling), then squeeze your hips and tighten your powerhouse as you hold your body vertically.

Inhale to prepare, then exhale as you lower your spine down one vertebra at a time.

Do 3–4 reps.

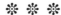

Pro Tip

(Skip this exercise if you have a bad neck, shoulders, or back.) Use the muscles of your powerhouse to keep your feet directly over your nose as you roll down. Keep pressing the back of your palms and arms into the mat when you lift your hips.

Benefits

Strengthens the powerhouse, buttocks, and hips.

Side Hustle (aka Side Kicks)

Lie on your side with your back lined up with the back edge of your mat; bend in your hips so your toes are lined up at the front of the mat.

Draw your powerhouse in and stack your shoulders and hips. Your head can be left down resting on your arm, or you can do the exercise while propped up on your forearm.

Lift your top leg to hover over your bottom foot.

Flex your top foot and sweep it forward in front of your hip toward your nose, while keeping it on the same plane as your hip.

Kick your foot 2 times forward and then sweep it behind you toward the back edge of the mat (keeping legs straight throughout).

Repeat 5 times on each side.

Pro Tip
Keep your hips and shoulders stacked and use your powerhouse.

Benefits
Strengthens the powerhouse, legs, and hips; also stretches the hips and legs.

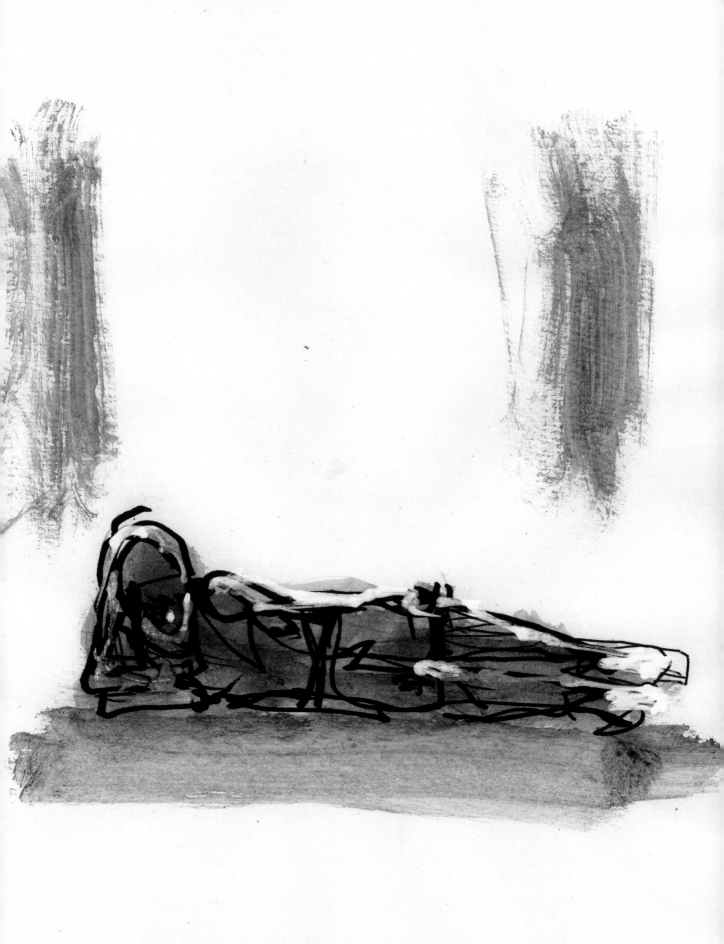

Deep Respect (aka Teaser)

Lie on your back with your feet in a Pilates stance—heels together with pointed toes no more than 3 fingers-width apart in a small "V."

Pull your powerhouse in, exhale, and lift your legs up slightly to hover just off the floor.

Inhale to extend your arms over your head, exhale, roll up, coming up into a seated V position with your eyes and toes at the same level.

Inhale at the top, then exhale to very slowly roll back down to the starting position with your feet and head hitting the mat at the same time.

Repeat 3 times.

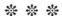

Pro Tip

Use your powerhouse to work in a slow, controlled manner.

Benefits

Strengthens the powerhouse and legs; improves balance and coordination.

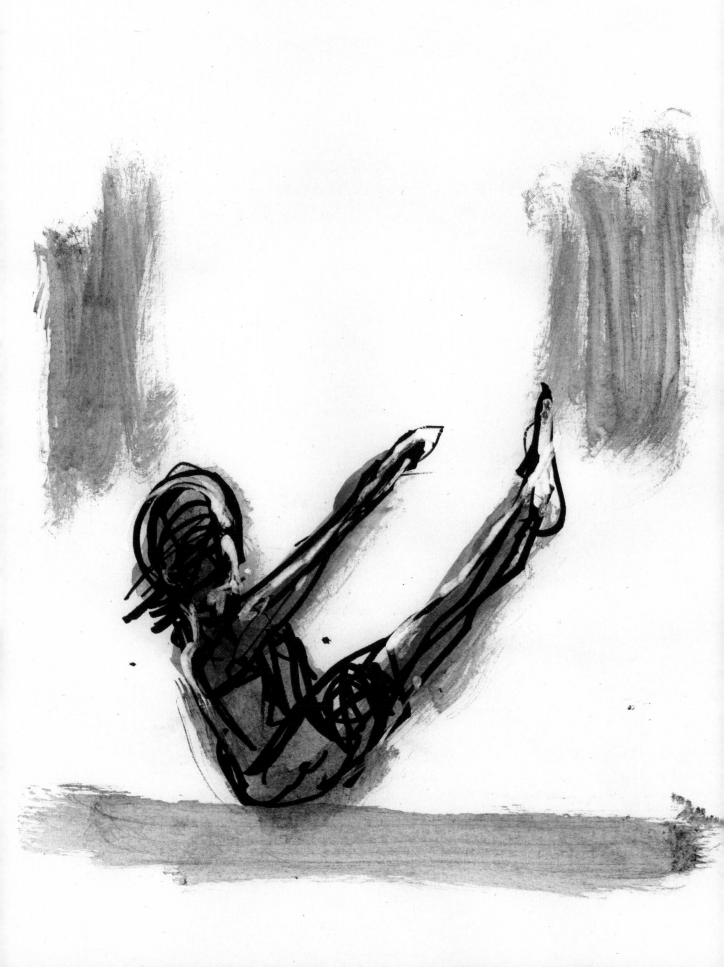

East Coast Love (aka Hip Circles)

Sit up tall, place your hands on the mat just behind your buttocks, and lift your legs straight up.

Inhale and swing your legs down and around and up in one full circle clockwise.

Repeat 3 times, then reverse direction.

Pro Tip

(Skip this exercise if you have a shoulder injury or a weak back.) Try to keep your back straight, chest lifted, and arms straight as your legs circle. Use your powerhouse to lift and circle your legs.

Benefits

Strengthens the powerhouse, hips, and legs.

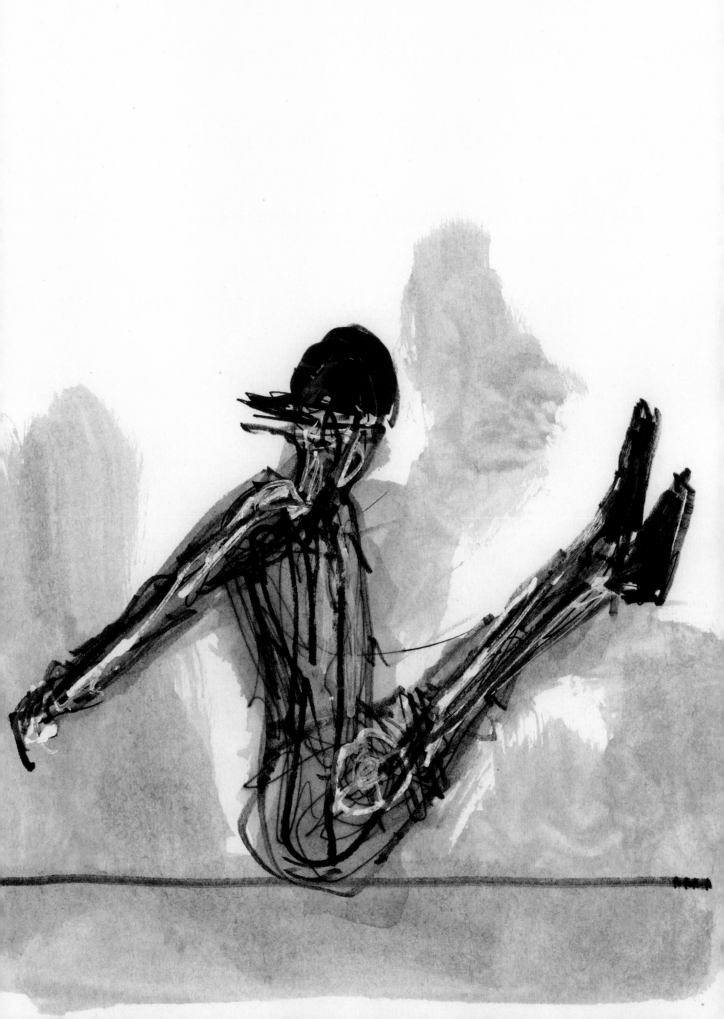

Burn Hollywood Burn (aka Swimming)

Lie flat on your stomach with arms extended straight out in front and straight legs extended behind you.

Elongate your spine, engage your powerhouse, and slowly begin to lift the opposite arm and leg at the same time (keeping arms and legs as straight as possible).

Switch arms and legs slowly until your coordination and rhythm sync up into a swimming-like motion.

Do 10 reps on each side.

Pro Tip

Maintain a strong lift in your powerhouse throughout the exercise, and extend your spine, arms, and legs. Squeeze your buttocks and hips to protect your lower back.

Benefits

Strengthens arms, legs, shoulders, back, and buttocks; also lengthens the spine and powerhouse.

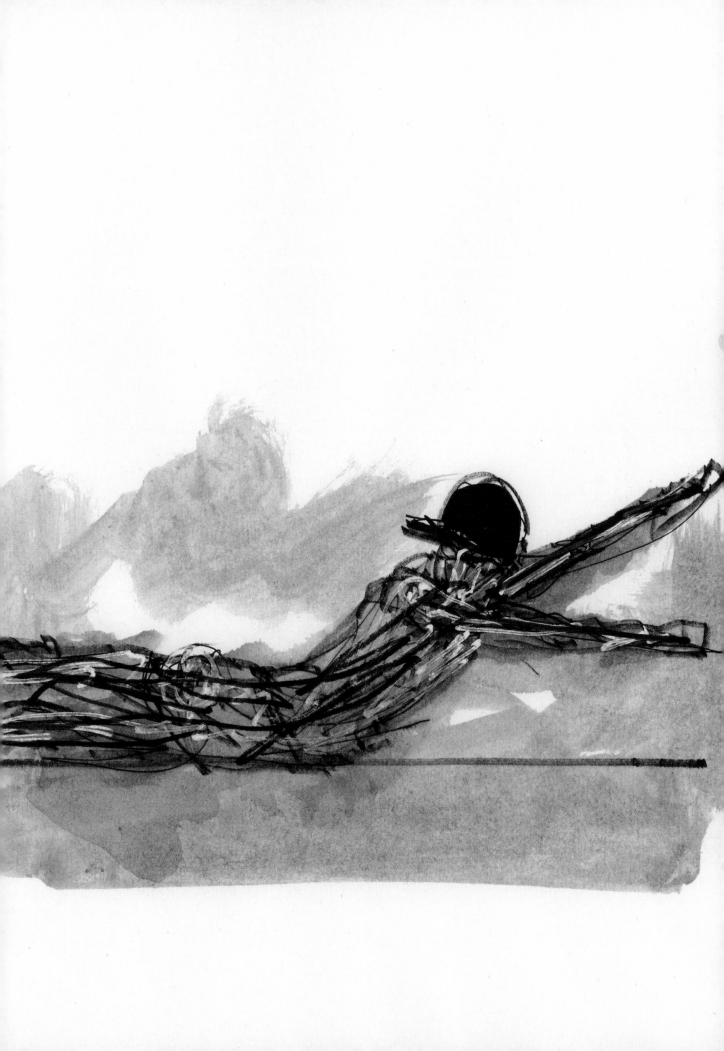

Shut 'Em Down (aka The Leg Pull-Down)

Start in a plank position and lift your right foot so it hovers over the mat.

Keep your right leg stable as you move your left heel back toward the mat, then exhale to pull your powerhouse in and roll your ankle forward, bringing your left heel back over your toes.

Exhale all the air out and lower your right leg back down to the mat.

Repeat on the other side.

Do 3 reps on each side.

Pro Tip

Keep your tailbone tucked and thighs and hips squeezed tight together.

Benefits

Strengthens the powerhouse, hips, arms, chest, back, and buttocks; also stretches the legs and ankles.

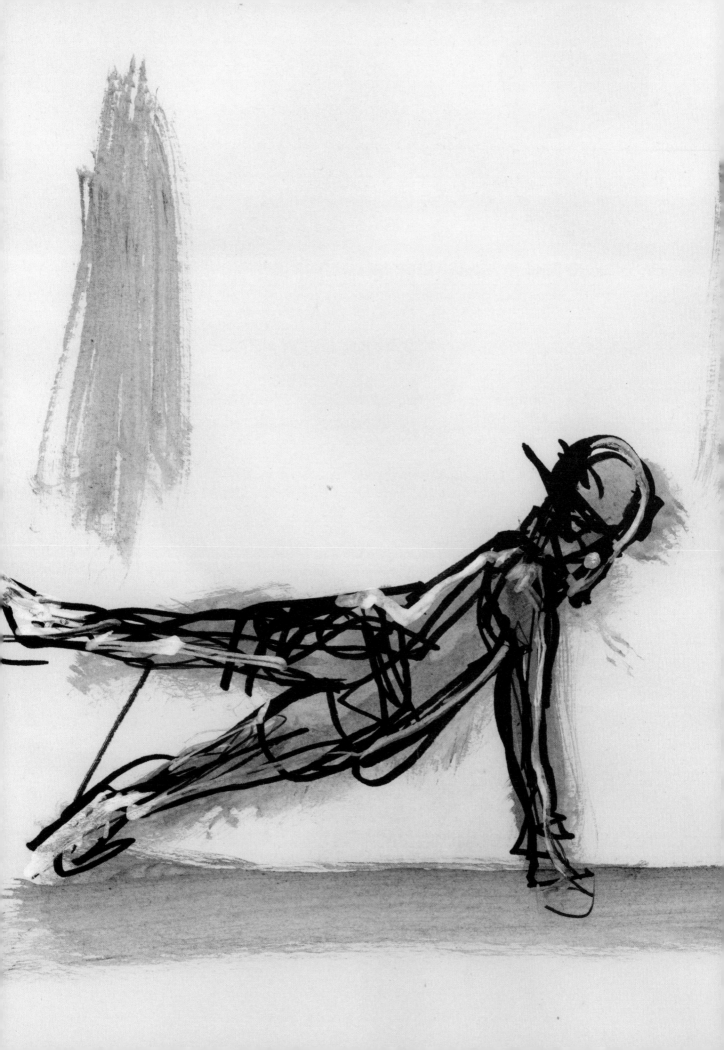

Welcome to the Terrordome (aka Leg Pull-Up)

Sit with your legs extended in front of you and hands under your shoulders on the mat, with your fingers pointed backward.

Lift your hips up off the mat and pull your powerhouse in as you lift your left leg straight up, engaging your hips and glutes.

Lower your leg and repeat with your right leg.

Pro Tip

(Skip this exercise if you have wrist or back problems.) Keep pushing into your arms and back so you don't sink into your wrists. Remain lifted in your powerhouse.

Benefits

Strengthens your upper body, lower body, and powerhouse.

He Got Game (aka Kneeling Side Kicks)

Kneel on your right hip and prop yourself up with your right hand on the mat, directly under your shoulder; lift your hip off the mat and balance on your right arm and leg. Your left hand should go behind your head with your elbow pointed up to the ceiling.

Extend your left leg straight out to the side.

Draw your abdominals in and keep your pelvis stable as you kick your left leg two times forward at hip height, then sweep it back behind you while staying on the same plane.

Do 5–10 reps.

Pro Tip

Stabilize your shoulders and hips and keep your foot on the same plane as your hip.

Benefits

Deep core muscles of the waist and hips are working overtime, and the emphasis is on balance, control, and coordination.

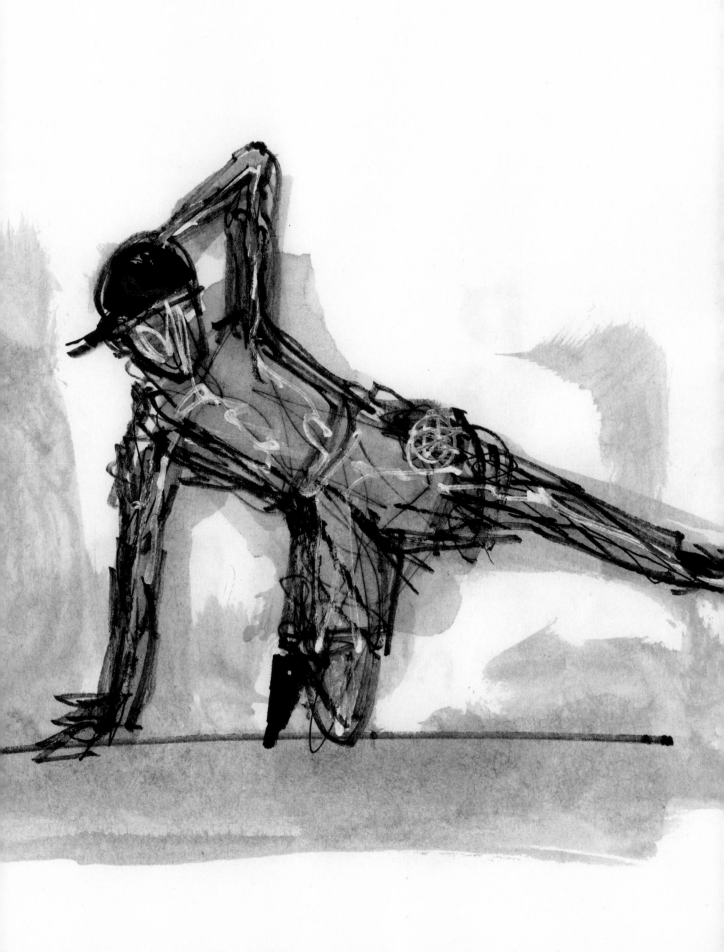

Terminator X (aka Side Bends)

Sit on your right hip, bend your knees slightly, and place your right hand flat on the mat, keeping your left arm long at your side.

As you inhale, pull your powerhouse in and simultaneously straighten your legs and lift your hips and body up in a straight line (a side plank position) while you reach your left arm up and overhead and look toward it.

Lower your left hand back down to your side.

Exhale as you lower your body back down.

Do this 5 times on each side.

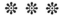

Pro Tip

Keep your hips square and aligned.

Benefits

Strengthens the upper body, waist, legs, arms, and power-house; also elongates the spine and improves balance and coordination.

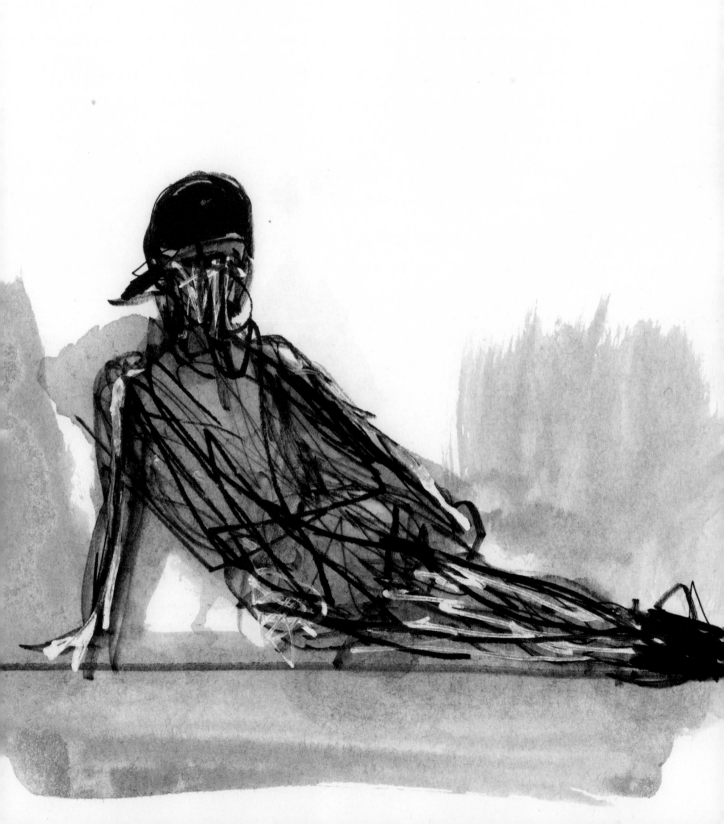

Show 'Em Whatcha Got (aka The Seal)

Sit on your mat with your knees bent, thread your hands between your legs, and grab onto your ankles, bringing your chin to your chest.

Pull your powerhouse in and rock back slightly to balance on your buttocks and lift your feet up in the air while still holding onto them.

Clap the soles of your feet together 3 times (like a seal!).

Inhale and roll backward onto your upper back.

Exhale and pull your powerhouse in as you roll back up and balance without letting your feet touch the mat.

Repeat 6 times.

❋ ❋ ❋

Pro Tip

Don't throw your head back; keep your chin nodded forward and roll back, engaging your lower abdominals and hips; practice control of your movement in both directions.

Benefits

Massages the spine and strengthens the back and powerhouse; also opens the hips and helps with balance and coordination.

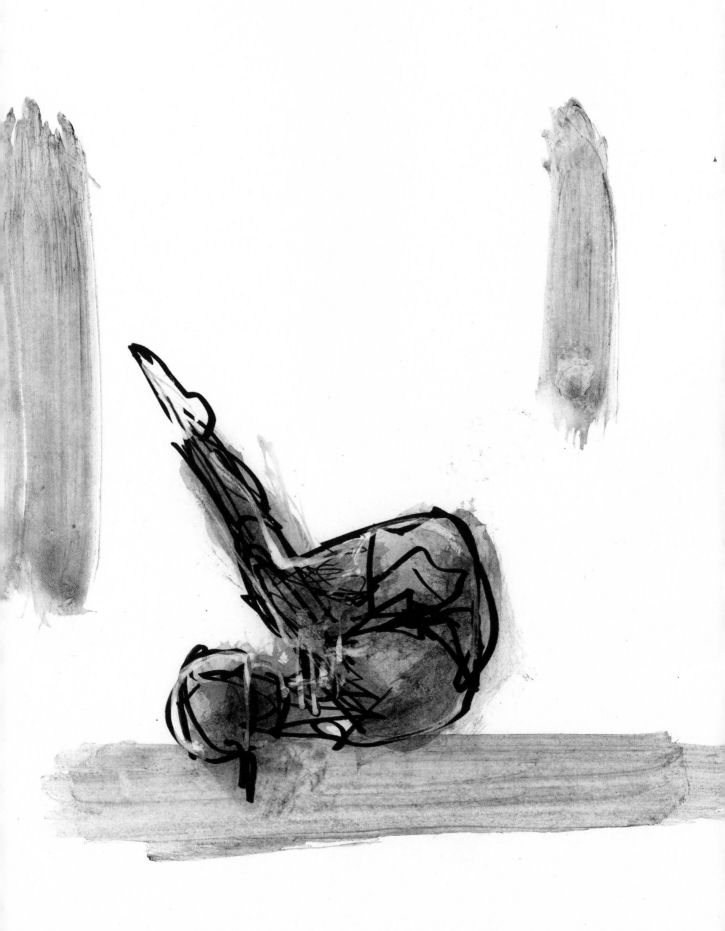

Cali Style (aka Pilates Push-Ups)

Stand up straight in a Pilates stance, then inhale and reach your hands up over your head.

Roll slowly down in a tall C-curve to the mat as you exhale, keeping your buttocks over your heels.

Exhale and reach your hands to the mat.

Walk out three hand spaces into a push-up (or plank) position.

Inhale and perform one push-up, then exhale and walk your hands back to the starting position.

Inhale again, then exhale and bend forward toward your legs, softening your knees.

Inhale and slowly roll up to the starting position.

Repeat 3 times.

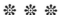

Pro Tip

Walk your hands out lightly to a push-up position and only lower yourself down to a point where you can press back up to a plank position.

Benefits

Strengthens the entire body; also aides in agility and flexibility.

We hope that this book inspires you to try Pilates, either at home or by joining a class. Above all, learn to breathe and never stop seeking better health.

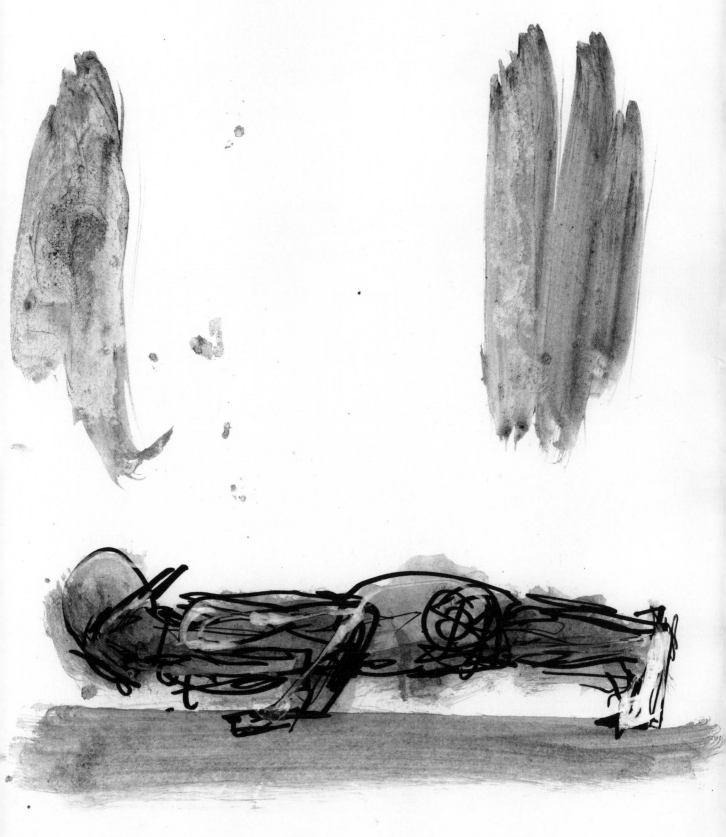

Glossary: Select Pilates Terms
by Kathy Lopez

Box: This term was used by Joe Pilates to refer to the line across your collarbone (from shoulder to shoulder) and the two lines that go down the sides of your torso and then cross your hip bones. The Pilates box is meant to bring awareness to your posture.

Button Up: This means to draw your ribs in and down—like you're buttoning up a vest that is too small and drawing your ribs inward to fit.

Cadillac: This started out as an experiment back in World War I in an internment camp on the Isle of Man where Joseph Pilates was imprisoned for four years because he was a German national. The Cadillac is roughly the height of a bed, and the springs for the original apparatus came from bedsprings—they would be attached to one's feet or arms with tied sheets. Joe trained ailing soldiers in this bed apparatus and taught them to use breathing and exercises to help heal their bodies. When the Cadillac was later developed for production, Joe added a trapeze, a roll-up bar, a push-through bar, and arm and leg springs.

C-Curve: This refers to the shape your body takes and maintains during certain Pilates exercises on the mat and Reformer. The C-curve position should be initiated by your abdominals. It sets the stage for a flexible spine and strong core.

Center/Centering: In class you will hear this a lot—"Return to your center," "Be always in your center," etc.—whether you are standing, sitting, or lying down. This means you should tune in to your pelvic area; breathe and place your mind there and move from that awareness and that space.

Imprinting: This is the action of rolling down your spine and articulating it into the mat or Reformer carriage, to improve your spinal alignment during certain Pilates movements. Imprinting correctly should release tightness, improve your posture, and help align your "box" (see definition above). You also get a deeper connection into all the muscles attached to your spine through imprinting and deep breathing.

Lateral Breathing: This type of conscious breathing emphasizes the lateral expansion of your rib cage and expands the intercostal muscles. It's done while maintaining a constant inward pull of your deep abdominal muscles as you breathe in and out.

Midline: This refers to the (imaginary) straight line that runs from the top of your head to the bottom of your feet, all along the spine.

Pilates Breathing: Joseph Pilates advised, "Above all, learn to breathe correctly." I frequently remind people about this quote when breathing becomes difficult during Pilates. We have enough stress and don't need to add breathing to the list! Proper breathing helps control your movements both during the Pilates exercises and in daily life. It gives you more stamina, allows for better concentration, and makes you feel more alive and alert. When we talk about breathing in Pilates, we mean effective, *conscious* breathing that expands your lungs fully with each inhalation and deflates them with each exhalation. There are essentially four phases of the Pilates breath: in-breath; pause, the still point in between; out-breath; pause, the second still point. When you concentrate on your breathing, you connect to a deeper level of yourself. Your breath is the bridge between your physical body and your very being. Breathing is an art form unto itself and is a focus in most meditation practices.

Pilates Stance: Thought of as a neutral position in Pilates, this is used to set up and prepare for an exercise. When in Pilates stance, your legs are together, straight and rotated outward from the tops of your thighs, bringing your heels together with your toes pointing slightly out (into a V shape, no more than three fingers wide). You can think of this as similar to first position in ballet, but not quite as extreme.

Powerhouse: This is your shoulder girdle, including your entire core from your upper rib cage to your lower pelvic area, pelvic-floor muscles, hips, and glutes.

Abdominal Muscles:

• *Transversus abdominis:* These muscles wrap around the trunk of your body, and when contracted, they give an hourglass waist. They are the deepest layer of muscles surrounding your spine, like a belt. Activating your transverse abdominal muscles feels as if you are hugging the midline of your center—like putting on a snug vest or corset. Their main responsibility is to protect internal organs, as well as to stabilize the torso, spine, and pelvis before any movement of the limbs can occur. Planks are a great exercise to engage the transversus abdominis when held for at least one minute.

• *Internal obliques:* These muscles start at your hip bones and go diagonally up toward your rib cage. They rotate and side-bend the body.

• *External obliques:* These muscles run diagonally from the rib cage down to the hip bone. They, too, rotate and side-bend the body. Together, the external and internal obliques create an X-like shape that wraps, hugs, and supports the center of your body.

• *Rectus abdominis:* These muscles form the outer layer of the body, known as the abs. The rectus abdominis are most visible with very low body fat and create that six-pack look when developed. They mimic the movement of the spine and flex the spine forward and backward.

Deep Back Muscles:

Semispinalis, Multifidus, Rotatores: Together, these deep back muscles create a chevron-shaped musculature. They attach to the back bones and side bones of the body. They are responsible for extension, rotation, and side-bending. When back muscles are weak, the spine can become compromised and result in back pain and various other issues. These muscles help stabilize the vertebral column, aid in balance, and help maintain posture.

Hip Flexor Muscles:

Psoas major, Psoas minor, Iliacus: These three muscles are what attach the thigh bone to the pelvis. The psoas attaches to the spine and crosses the hip flexor, supporting the body's upper extremities and lifting the legs in conjunction with the abdominals. Modern life puts a lot of stress on the hip flexor muscles and consequently pulls the spine into forward flexion if they are weak, causing back issues.

Reformer: This is probably the most widely known Pilates apparatus, aside from the mat. The Reformer's unique combination of springs, pulleys, straps, and sliding carriage make it incredibly versatile.

Like most Pilates equipment, the Reformer differs from traditional fitness equipment in fundamental ways. Rather than using an isolated set of muscles to move an external force, such as how most weight-training machines work, you use your powerhouse to lift and pull your body's weight along with the Reformer's spring-loaded carriage. This action automatically centers you and helps develop balance and coordination, as well as body and spacial awareness. At the same time,

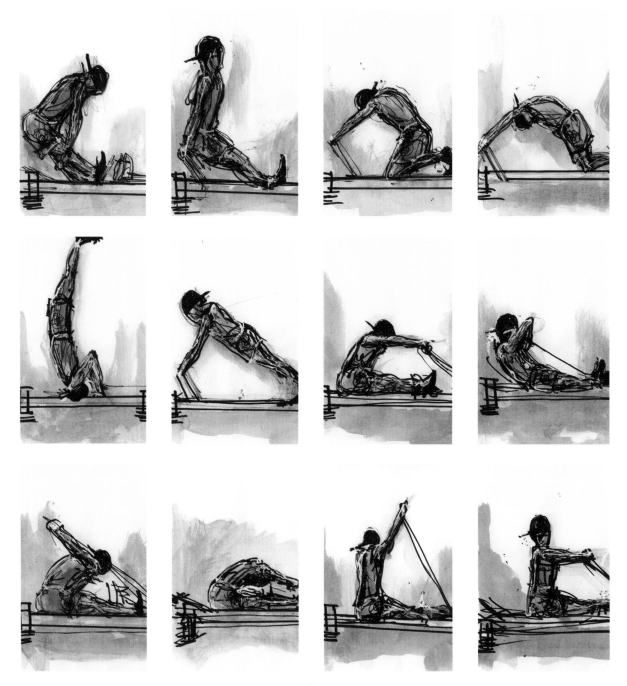

it strengthens and stretches your entire body, not just one isolated set of muscles.

When Joe Pilates developed a series of exercises for the Reformer, he intended for them to be performed in a specific sequence and manner, resulting in a succession of constant, flowing movements. This is done while inhaling and exhaling for thirty to sixty minutes during a nonstop workout.

Each Reformer exercise prepares your mind and body for the next one. Warming up your muscles, awakening your mind and body, stimulating your organs, coordinating your breathing, and training your muscles to "fire" in the correct sequence will give you the maximum fitness benefits.

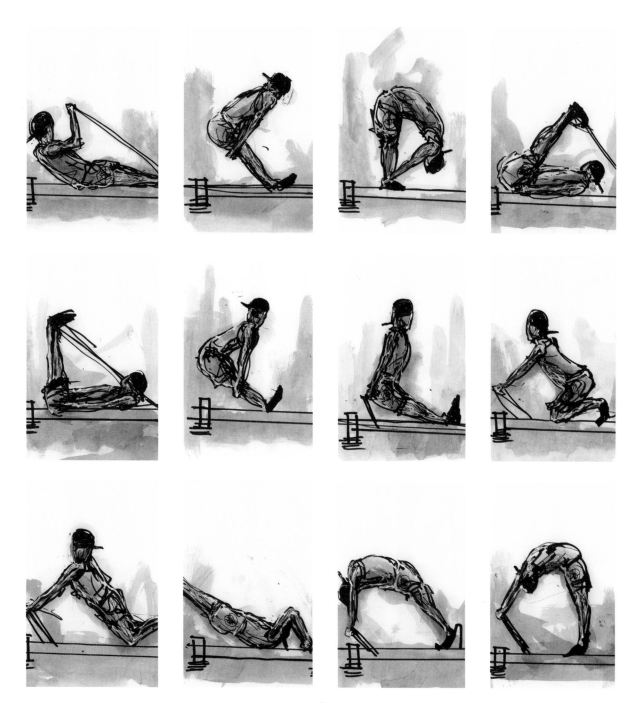

Scoop Abs: When you perform an abdominal scoop, you engage your pelvic floor and pull your abs inward, and at the same time draw your belly button down toward your spine.

Wunda Chair: In the Pilates system there are two main types of chairs: the Wunda chair (also known as the low chair) and the high chair. The main difference is that the high chair has a back and two handles that rise on either side, while the Wunda chair does not. The Wunda chair has a simplistic design, consisting of a box with a padded top and a pedal on one side that moves against the resistance of springs anchored to the opposite side of the chair. I typically use the Wunda chair for group classes with students who already have a good understanding of Pilates. Having said that, the chair's versatile design enables many people to get amazing results, from beginners and injured students to the most advanced students challenging themselves with push-ups, backbends, and pull-ups.

Zipper/Zippering: This motion draws your abdominals in and up, like you're zipping up a vest.

Chuck D is the leader and cofounder of the legendary rap group Public Enemy, a social activist, multimedia producer, visual artist, and digital music pioneer. He has been featured in more than one hundred documentaries on music, technology, politics, and race, and cocurated the *Smithsonian Anthology of Hip-Hop and Rap*. He has also been a national spokesperson for Rock the Vote, the National Urban League, Americans for the Arts, and the National Alliance of African American Athletes. As part of Public Enemy, he was inducted into the Rock & Roll Hall of Fame and earned a Grammy Lifetime Achievement Award. He is the author and illustrator of *STEWdio* and *Summer of Hamn*.

Kathy Lopez earned comprehensive certifications from BASI and Power Pilates in 2001 and 2009. She also studied and trained to further her understanding of the classical method with the prestigious Romana's program, and holds a Yoga certification based in the Iyengar method. She is the founder of Studio Be Pilates in Ventura, CA, and resides in Ojai, CA.

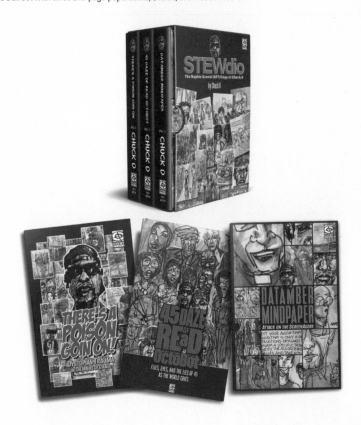